ANIMAL EMOTIONS

PHOTOGRAPHS BY JUDITH HAMILTON

When I read Charles Darwin's book, "The Expression of the Emotions in Man and Animals" published in 1872, I was amazed to learn that people at that time thought animals did not have emotions. As I studied my photographs of wild animals I could definitely see expressions like curiosity, affection, fear, and suspicion. This recognition led me to create my first book, "Animal Expressions" combining my wildlife photographs with appropriate quotations.

I enjoyed the making of that book so much that I have created this second book, "Animal Emotions." This book includes some of my recent wildlife photographs with different quotations, and adds a few facts about the various subjects.

Many of these photographs were taken at some of the 550 sites around the world where Wildlife Conservation Society (WCS.org) works to save wildlife and habitats. The proceeds from this book will be donated to WCS to help them continue their work.

Judith Hamilton, January 2020

Animals share with us the privilege of having a soul.

PYTHAGORAS

MONDIKA NATIONAL PARK | REPUBLIC OF CONGO
Lowland gorillas are found in the forests of Gabon, Cameroon, Central Africa Republic, Democratic Republic of Congo, Angola, and Republic of Congo. The leader of a troop of gorillas is a silverback male. This dominant male leads the troop to find food, tells them when to stop and build a nest to sleep, and keeps order among the many females by standing and beating on his chest when they squabble. Any gorilla you see in a zoo is a lowland gorilla.

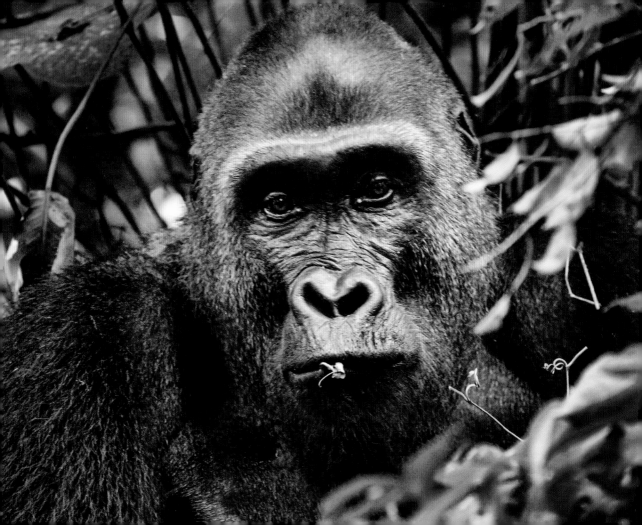

Everything has beauty but not everyone sees it.

CONFUCIUS

Black rhinoceros live in the grass and flood lands of eastern and southern Africa. These huge vegetarians can weigh up to 5000 pounds and live for 45 years in the wild. Female rhinos usually have one baby every two and a half to five years and these hefty newborns tip the scales at 90 to 140 pounds. Babies stay with their mothers for about three years. Rhinos are endangered with only about 5000 roaming free today.

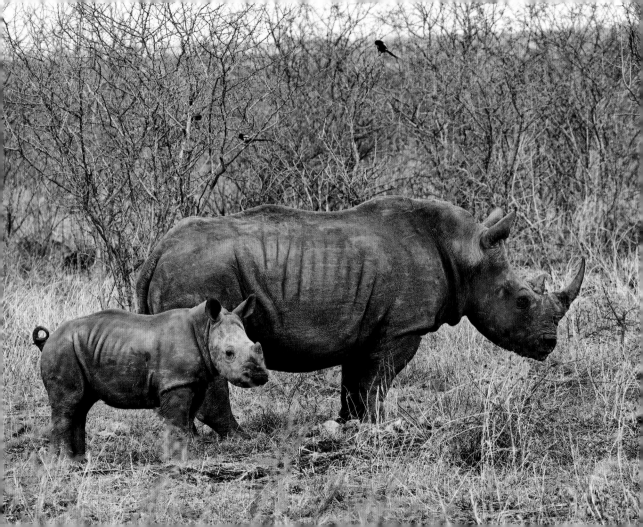

It is neither wealth nor splendor but tranquility and occupation which give happiness.

THOMAS JEFFERSON

JAO RESERVE | BOTSWANA
African leopards are excellent tree climbers and often drag their prey, such as impala, up into the high branches to protect it from hyenas or lions. They sleep frequently in trees during the day and hunt at night.

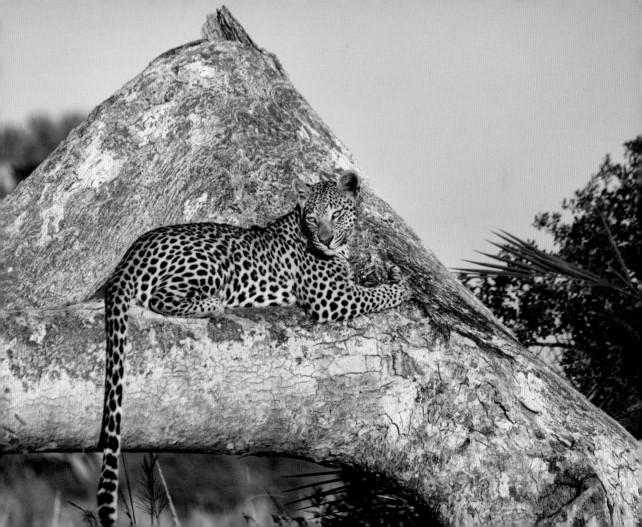

Part of success in life is eating what you want.

MARK TWAIN

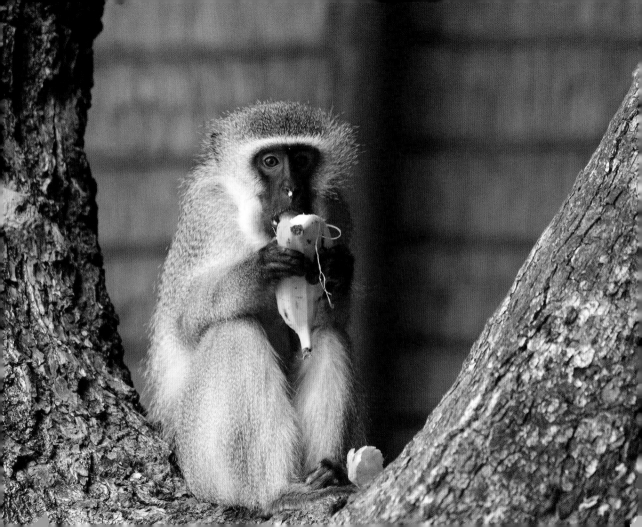

Sometimes you just have to shake it off.

TAYLOR SWIFT

The polar bear is the largest land carnivore. These bears are found in Canada, Russia, Greenland, and Arctic areas of Norway and Alaska. They have an amazing sense of smell and sight and use them to sneak up on their prey, primarily seals. Polar bears have black skin and hollow, translucent fur. It is simply the reflection of light which causes them to look white.

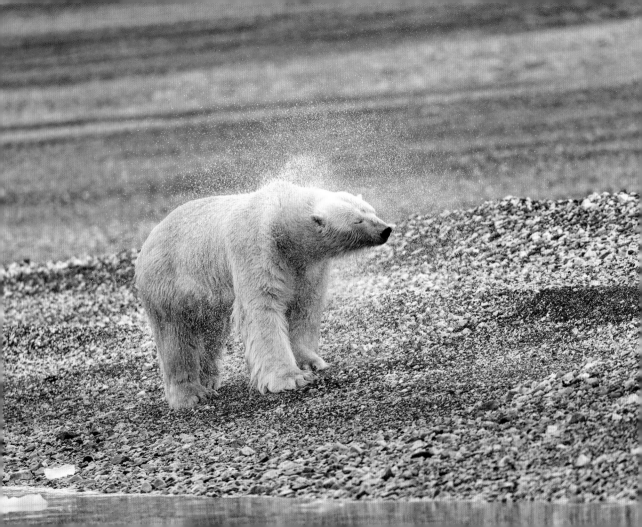

A family is one of nature's masterpieces.

GEORGE SANTAYANA

LONDOLOZI PRIVATE GAME RESERVE | SOUTH AFRICA

African lions are the most social of all big cats and live in groups called prides. The pride usually consists of up to 15 lions and is made up of females, young males, and a dominate adult male. The other males leave the pride when they are about two years old and often join other males in what is called a coalition.

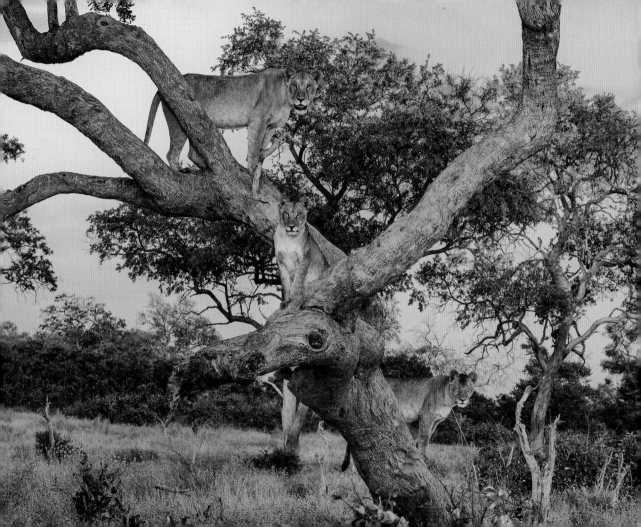

Bravery is all well and good but sometimes it is much better to be cautious

ANDRE CREMER

MAKGADIKGADI SALT PAN | KALAHARI DESERT | BOTSWANA
Meerkats are part of the mongoose family and are found in the Kalahari and Namibia Deserts. They live in burrows underground in groups called mobs or gangs of 15 to 50 animals. These complex structures can have as many as 15 different entrances and there are separate chambers for waste elimination, sleeping, plus a nursery for babies.

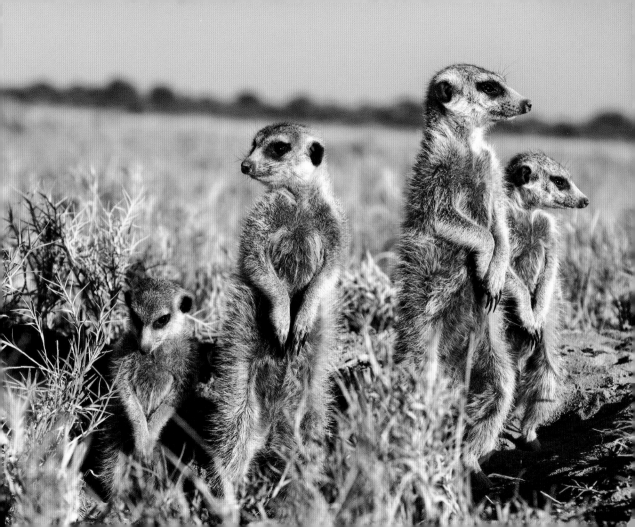

Life and death are one thread, the same line viewed from different sides.

LAO TZU

Vultures live in most parts of the world. They could be called nature's garbage men because they are scavengers and mostly eat dead animals and fish. They have a type of acid in their stomachs allowing them to eat meat that would make other birds and animals sick.

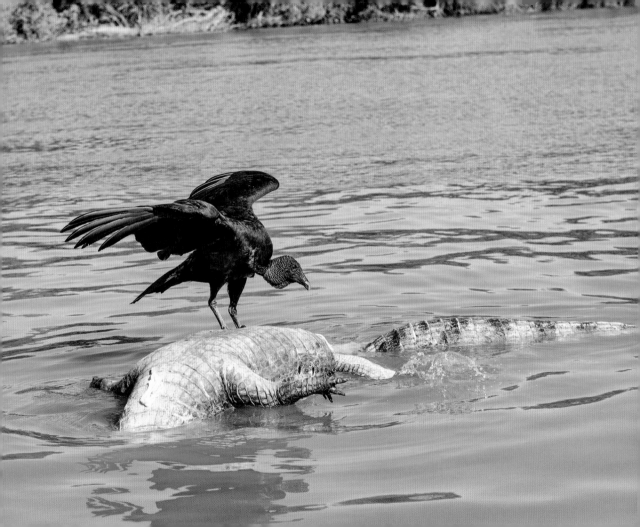

We cannot see our own reflection in running water.
It is only in still water that we can see.

ZEN PROVERB

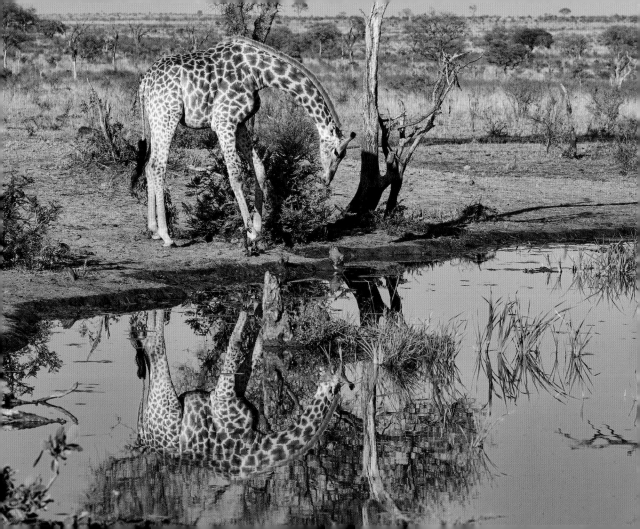

Life is either a daring adventure or nothing.

HELEN KELLER

CUIABA RIVER | PANTANAL, BRAZIL

Jaguars, the largest cats in the Americas, are found in Central and South America from Northern Argentina to Mexico. Lately there has also been a sighting in Arizona. The jaguar often leaps into water to ambush prey, such as otters and caiman. In ancient Mayan and Aztec mythology, the jaguar is a symbol of strength.

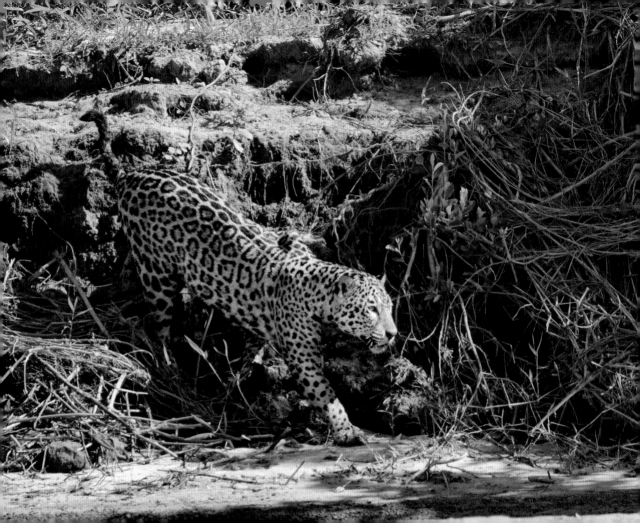

**Promise me you will always remember:
You are braver than you believe and stronger than
you seem and smarter than you think.**

A. A. MILNE

When these adolescent grizzlies mature, they could stand up to eight feet tall and weigh as much as
800 pounds. Grizzlies are found throughout North America from Alaska to the northwestern part of the United
States. Their diet is mainly clams, fish, plants and insects. Moths are especially delicious to grizzlies. They have
been seen in Montana's Glacier Park spending up to 14 hours in a day devouring about 40,000 moths!!

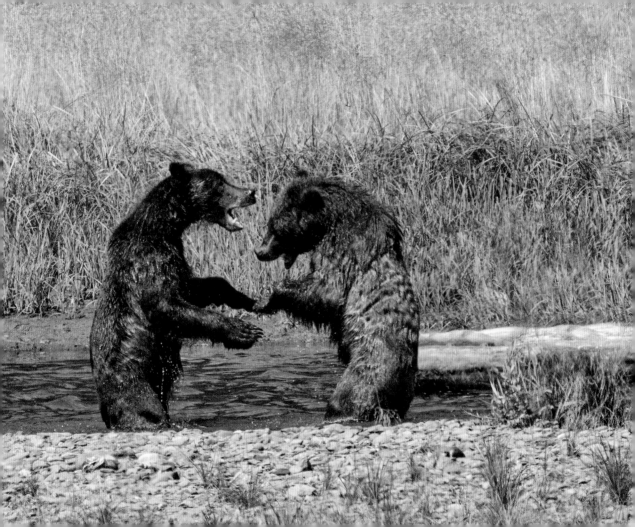

You love most of all those who need you.

RAINER MARIA RILKE

KUKA HILLS, SERENGETI | TANZANIA

Hyenas are neither dogs nor cats, but are a unique species living in Africa and Asia. They live in underground dens in groups as large as 130 individuals called clans. Hyena society is matriarchal. In fact, females have three times the testosterone as males. In times past, the Maasai people of Kenya and Tanzania left their dead to be consumed by hyenas rather than bury them.

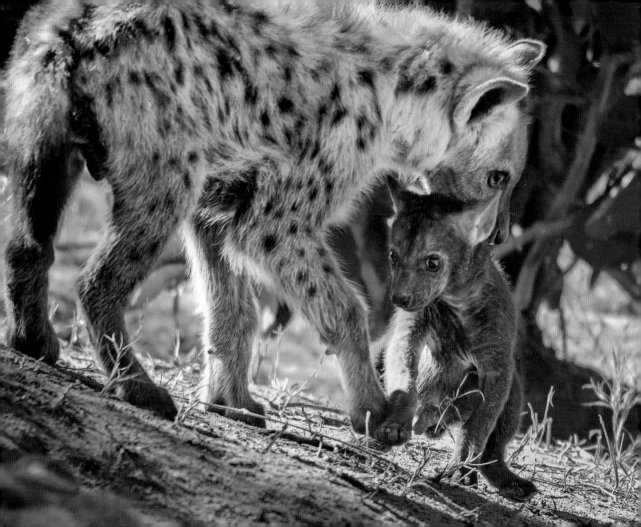

We are such stuff as dreams are made on and our little life is rounded with a sleep.

WILLIAM SHAKESPEARE

The Northern Hemisphere Arctic fox can endure temperatures as low as -58 degrees Fahrenheit. They are solitary animals living on tundra and ice packs. They do not hibernate and their fur turns color with the seasons. In summer, the fox is grey and blends in with the rocks. In winter its fur turns white making it invisible on the snow.

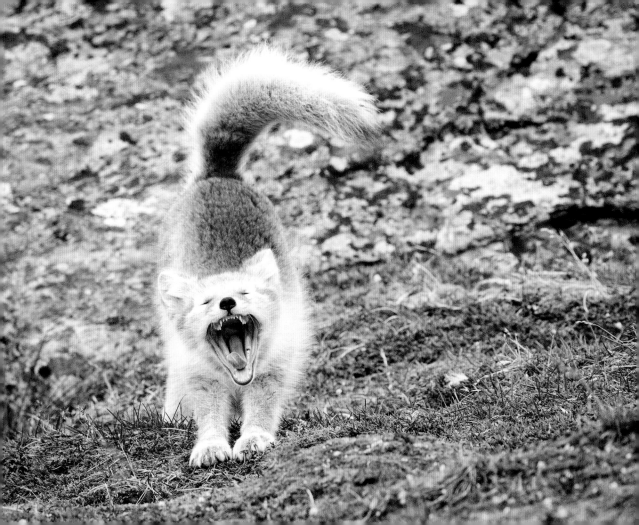

An early morning walk is a blessing for a whole day.

HENRY DAVID THOREAU

The ostrich is the world's largest bird, and it cannot fly. Ostriches are the fastest runners of any bird or any other animal with two legs. They can sprint at over 45 miles per hour covering up to 155 feet in one stride. Male and female ostriches cooperate in rearing chicks.

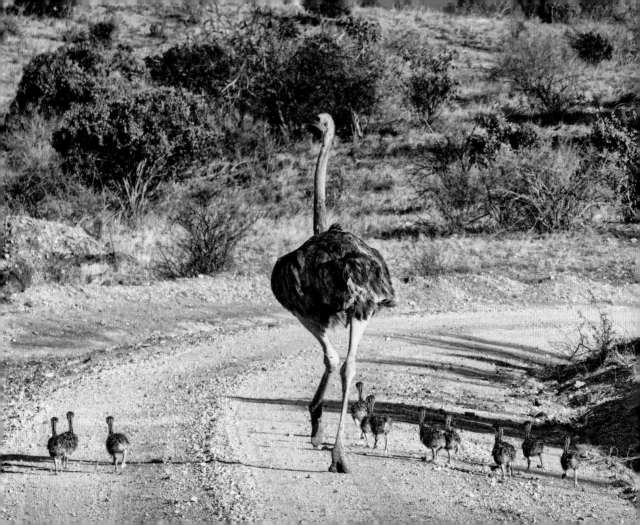

Do not judge me by my success. Judge me by how many times I fall down and get back up.

NELSON MANDELA

Bison are North America's largest land animal. At one time, an estimated 30 to 60 million bison ranged from Canada to Mexico but by 1890 due to hunting, only about 1000 remained. In 1907, in order to stabilize the population, Theodore Roosevelt and the Bronx Zoo shipped by railroad a herd from New York to Montana. Today several thousand bison roam the west.

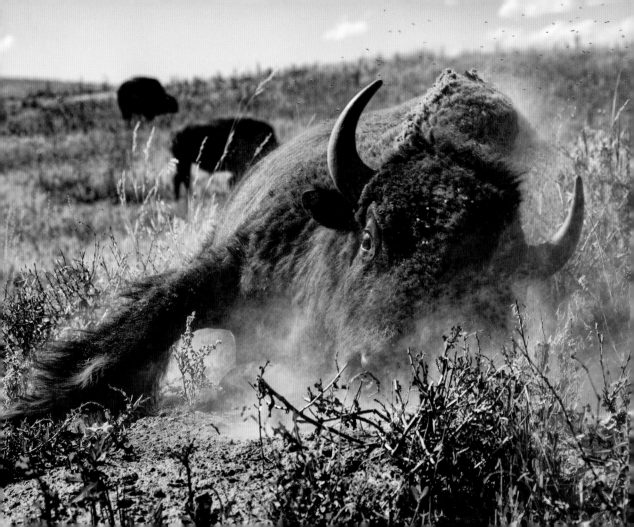

No matter how long you have traveled in the wrong direction, you can always turn around.

MARK TWAIN

VUMBURA PLAINS | OKAVANGO DELTA | BOTSWANA
Leopards in Africa live south of the Sahara Desert. They are solitary animals except for pairs during mating and mothers with young cubs. To protect the large territory they need to survive, they leave claw marks and urine on bordering trees to warn other leopards to stay out.

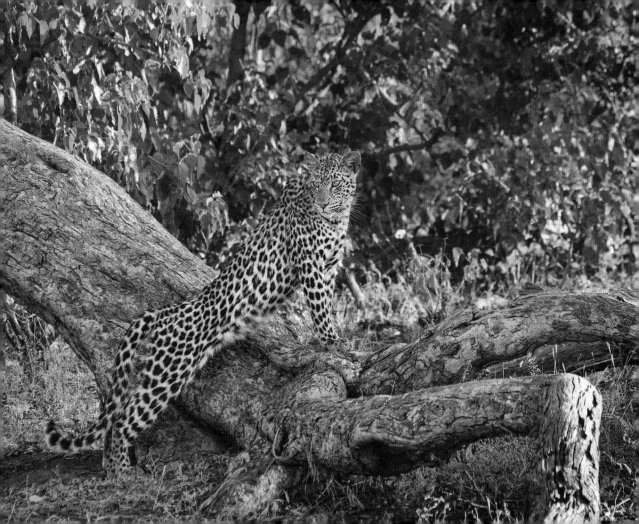

When in doubt, take a bath.

MAE WEST

Roseate spoonbills get their beautiful coloring from the foods they eat. Parts of their diet of crustaceans and other aquatic invertebrates contain pigments called carotenoids that help turn spoonbills' feathers pink.

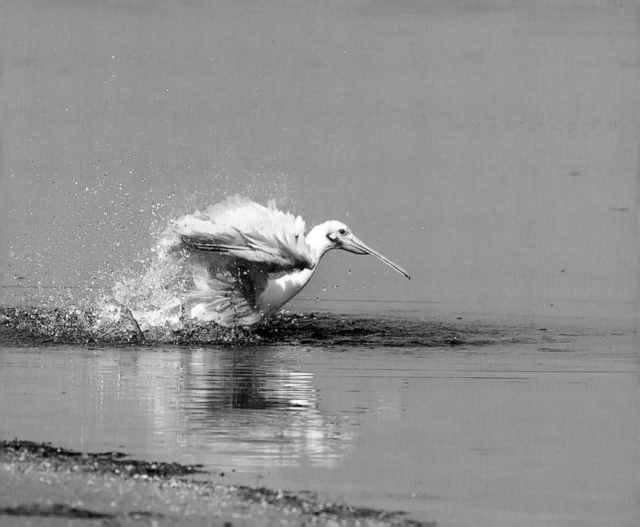

My mother had a great deal of trouble with me, but I think she enjoyed it.

MARK TWAIN

Lion cubs are born with spots that disappear as they get older. Usually two or three cubs are born in a litter, but there may be as many as six. The mother keeps them hidden in underbrush for up to eight weeks before they get introduced to other lions in the pride. They are fully grown in three to four years, and begin to hunt after two years.

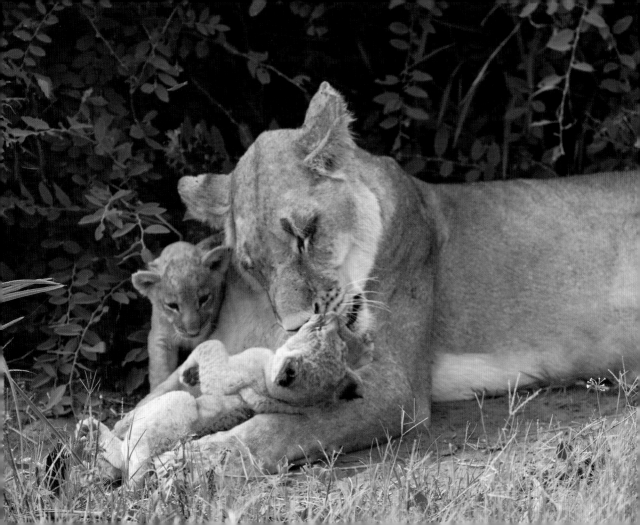

A thing of beauty is a joy forever.

JOHN KEATS

CENTRAL PARK ZOO | NEW YORK | NEW YORK
The snow leopard is the only large cat living in the high mountains in Asia. They are solitary and rarely seen.
Their bodies are designed to survive the cold. The fur on their stomachs is five inches thick, and they
can wrap their massive tails around themselves to act as a protective shield against the severe weather.
Snow Leopards are endangered and only about 4000 exist in the wild.

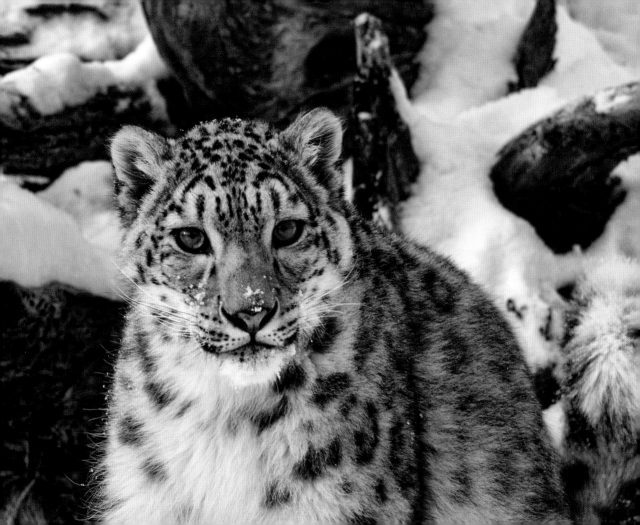

Running just as fast as we can...
Trying to get away into the night...

RITCHIE CORDELL

MAKALOLO PLAINS | HWANGE NATIONAL PARK | ZIMBABWE

In the impala antelope society, one dominate male has power over his multitude of females and their young, with his herd numbering as many as 200. When the young males are old enough to challenge the master, he forces them out of his herd and these bachelors band together in their own herds for mutual protection. Impalas, wishing to cross over suspicious water where there may be lurking crocodiles looking for a tasty meal, run as fast as they can and leap as high as possible for safety.

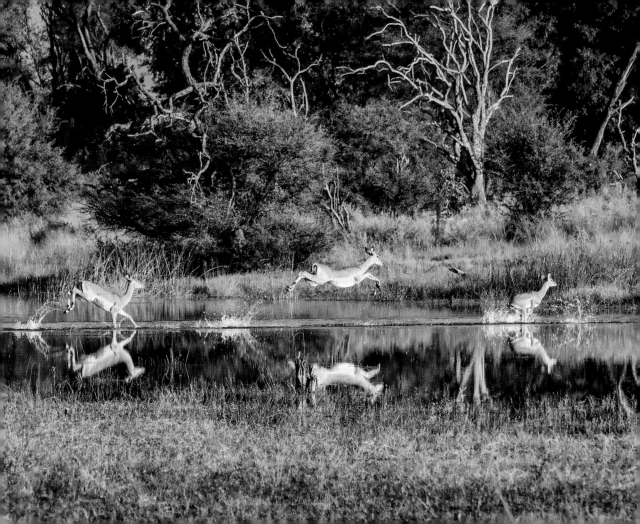

One travels more usefully when he is alone because he reflects more.

THOMAS JEFFERSON

MAKALOLO PLAINS | HWANGE NATIONAL PARK | ZIMBABWE
Wild dogs, also called painted dogs, split off from the canine lineage almost two million years ago. Their trumpet-like ears give them excellent hearing to aid in hunting. They don't bark or howl but make twittering and sneezing sounds. Running as fast as 45 miles per hour, on their skinny long legs with only four toes per foot, they hunt very successfully as a pack.

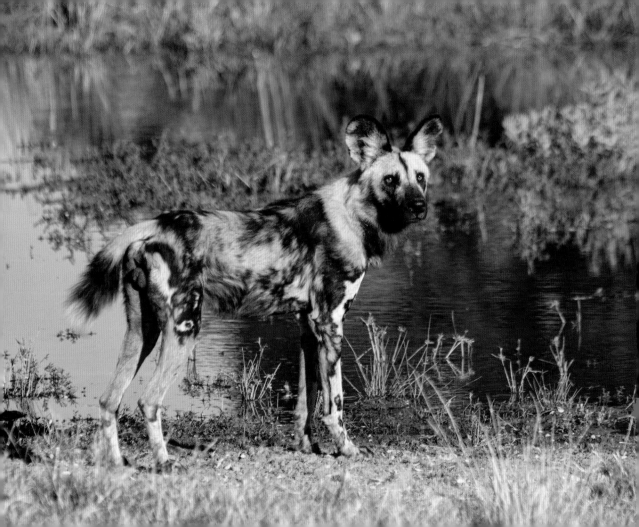

Men do not quit playing because they grow old; they grow old because they quit playing.

OLIVER WENDELL HOLMES

COOKS INLET | ALASKA

Female grizzly bears have one to four cubs which are born in hibernation while the mother is asleep. The cubs stay with their mothers two to four years. These bears have excellent memories. They can remember food spots for years. Their eyesight and smell are excellent and it is not unusual for grizzlies in the wild to reach the ripe old age of thirty.

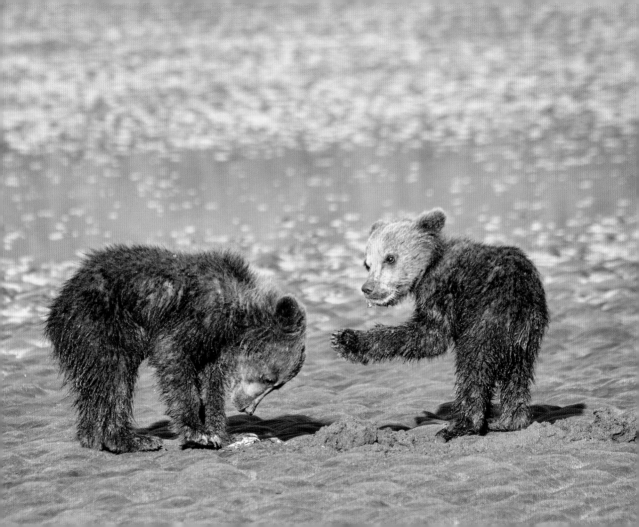

It is not only fine feathers that make fine birds.

AESOP

PORTOLA VALLEY | CALIFORNIA | USA
There are over 330 hummingbird species found in the Americas. The name comes from the sound their wings make when they are flying, which is most of the time. They are the only bird that can fly backward. And to conserve energy, hummingbirds enter a hibernation like sleep called torpor every night.

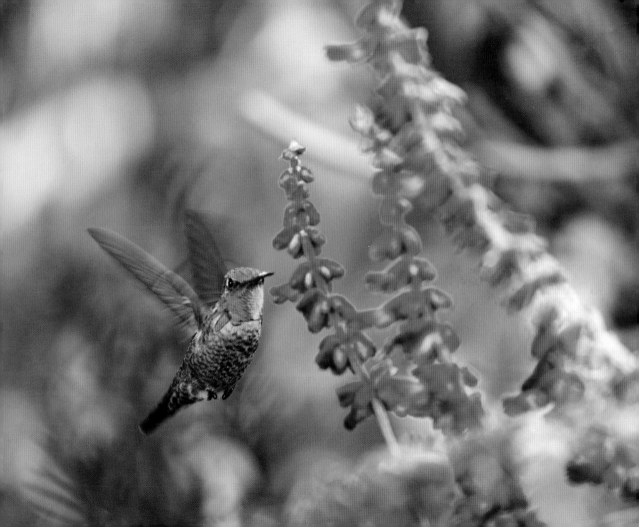

A baby is an inestimable blessing and a bother.

MARK TWAIN

Giant anteaters have no teeth but with their long and sticky tongues they eat up to 35,000 ants and termites a day. The giant anteater can be seven feet long from its snout to the end of its tail. A female has one baby at a time and carries it around on her back where it is well camouflaged.

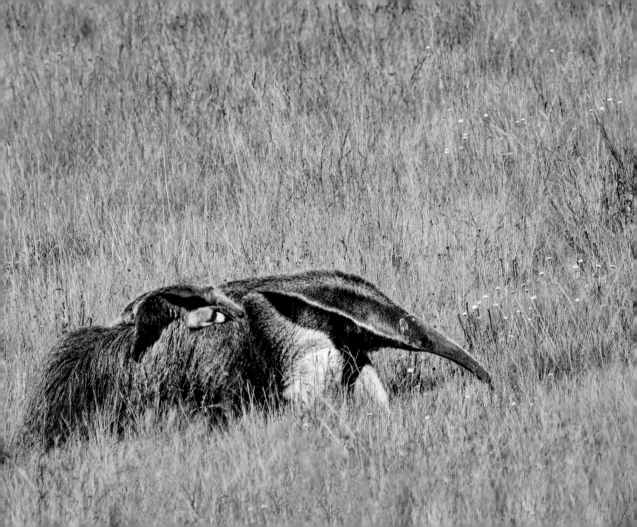

To climb a tree is to discover a new world.

FREDRICH FROEBEL

VINCE SHUTE WILDLIFE SANCTUARY | MINNESOTA | USA

Living mostly in forests from Canada to Mexico, the black bear feeds on insects, fish, small animals, fruits, nuts, and other plants. Of the three North American bears, polar, black and grizzly, black bears are the smallest. They are excellent tree climbers, even as cubs and live on average 18 years in the wild.

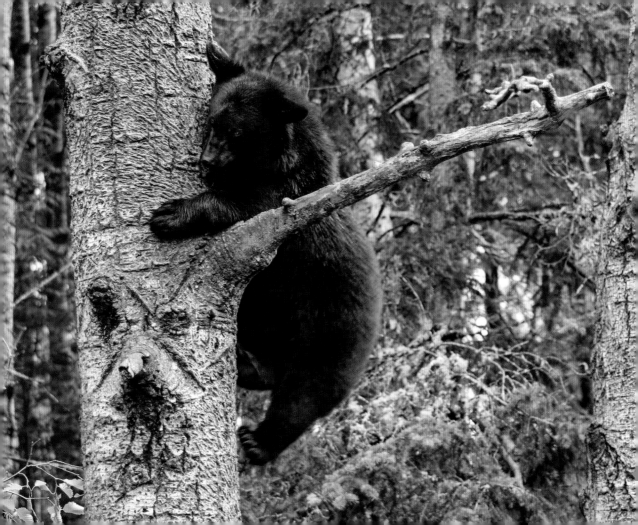

You are never too old to set a new goal or to dream a new dream.

C. S. LEWIS

LINYANTI WILDLIFE RESERVE | BOTSWANA
Only male lions grow manes. A good measure of a lion's age is the darkness of his mane—the darker the mane, the older the lion. The mane makes the lion appear larger, and therefore more intimidating. And the thickness of the mane protects the lion's neck when it is fighting with other lions or hunting. Female lions are attracted to males with bigger, darker manes.

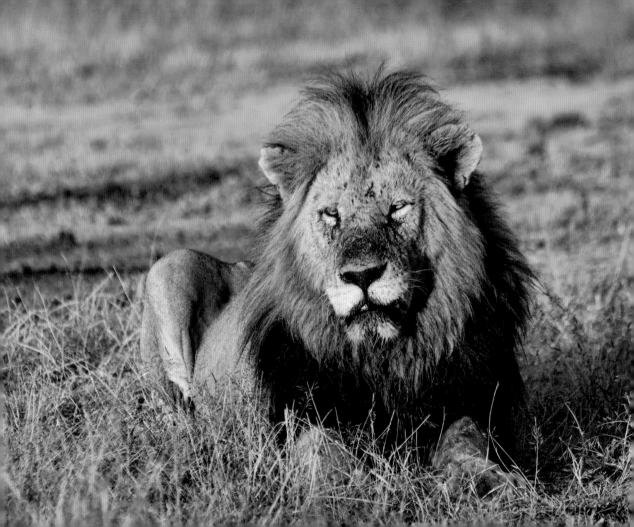

Whatever else is unsure in this world, a mother's love is not.

JAMES JOYCE

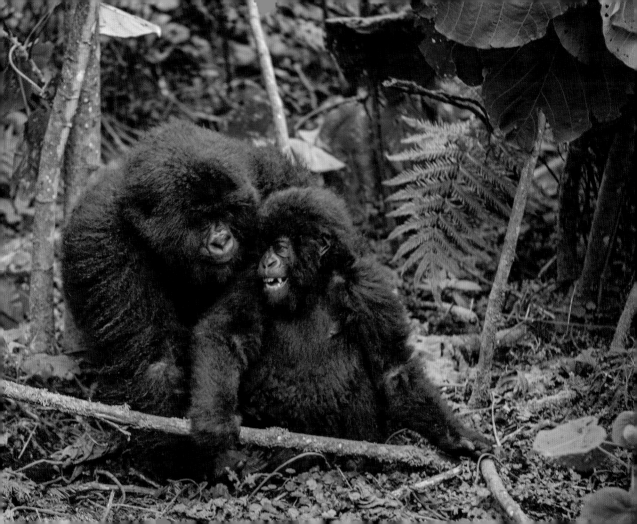

Rejoice with your family in the beautiful land of life.

ALBERT EINSTEIN

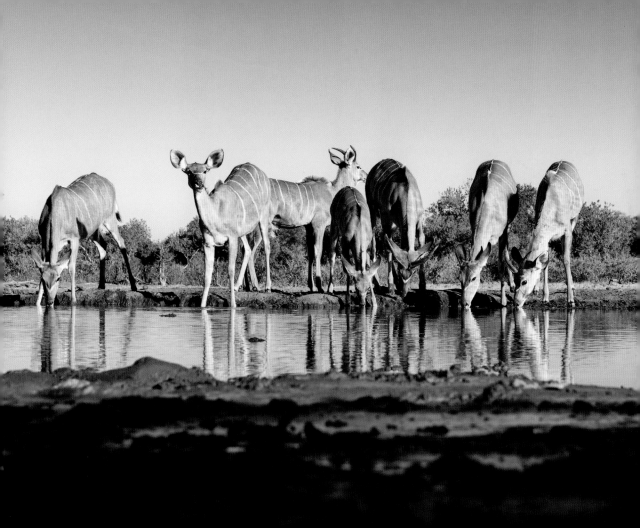

One of the best things you can learn in life is to master how to remain calm.

BRUCE LEE

JAO RESERVE | BOTSWANA
African leopards have unique spots, like humans' fingerprints. Pound for pound, the leopard is the strongest of the big cats. They are known for their agility and are strong swimmers. They can run up to 58 miles per hour and jump 20 feet horizontally and 10 feet vertically.

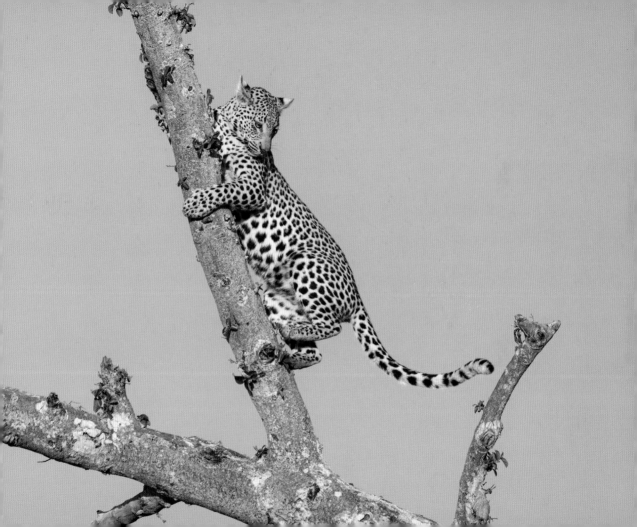

What you do not want done to yourself, do not do to others.

CONFUCIUS

MOREMI GAME RESERVE | OKAVANGO DELTA | BOTSWANA
Hyenas are very intelligent and very social. A study at Duke University showed them performing intelligence tests better than chimpanzees. The saying "laughing like a hyena" comes from the sounds they make to communicate with each other which sounds like high pitched human laughter.

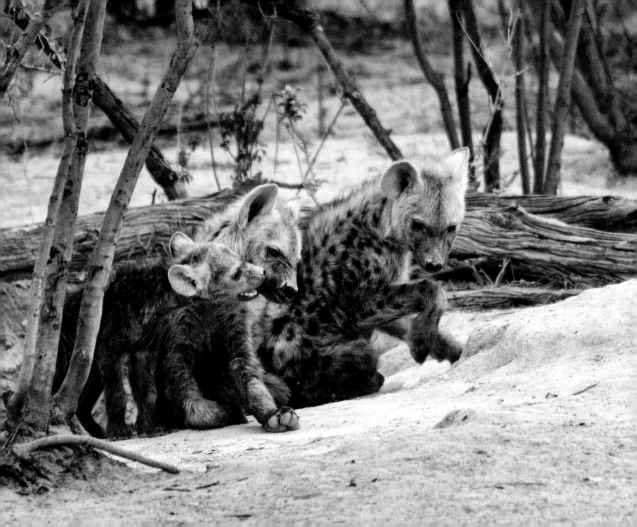

You cannot step in the same river twice.

HERACLITUS

CHIEF'S ISLAND | OKAVANGO DELTA | BOTSWANA
In a pride of lions, the females do up to 90 percent of the hunting while the males defend the pride's territory.
Most of the hunting is done from dusk to dawn and a lion's night vision is six times better than a human's.

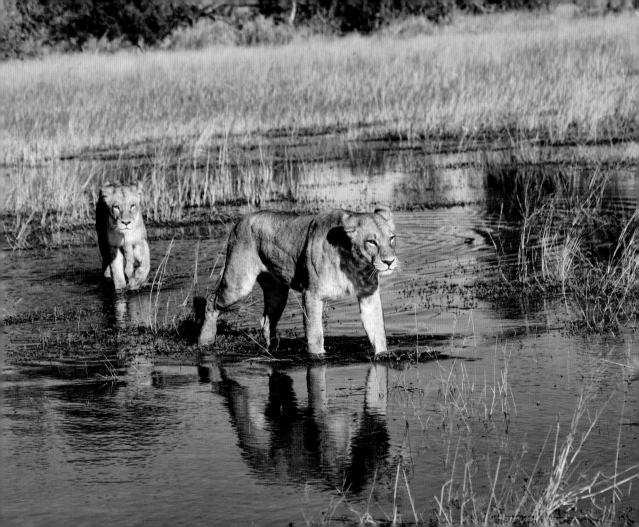

By three methods may we gain wisdom:
First is reflection, which is noblest.
Second is imitation, which is easiest.
And third by experience, which is the bitterest.

CONFUCIUS

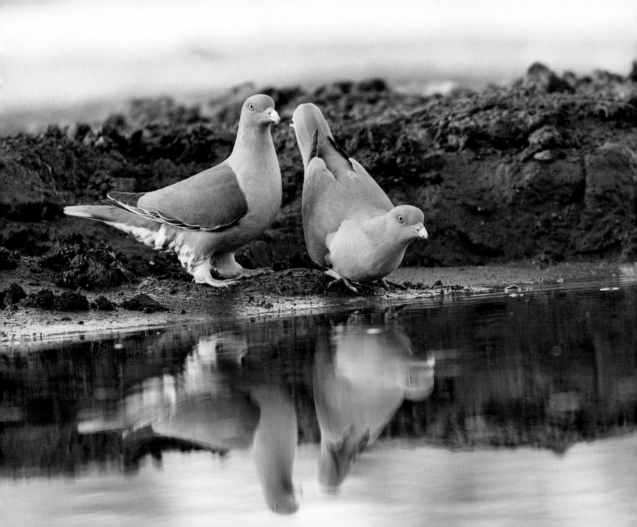

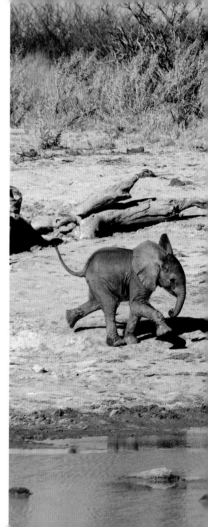

You don't chose your family. They are God's gift to you as you are to them.

DESMOND TUTU

TARANGUIRE NATIONAL PARK | TANZANIA
African savannah elephants live in herds of up to 100 females and young males led by a matriarch. The females will stay in the herd for life, but the males will leave at about age three and go off to lead a solitary life or to join a bachelor group.

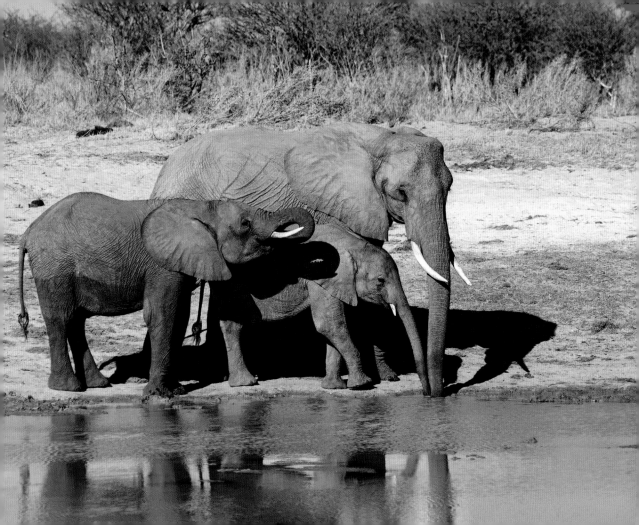

If you are in a bad mood, go for a walk.
If you are still in a bad mood, go for another walk.

HIPPOCRATES

TARANGUIRE NATIONAL PARK | TANZANIA
Hyenas are both hunters and scavengers. They hunt up to 95 per cent of what they eat, but they also steal game from other animals, like the leopard. They have incredibly strong jaws, and a few hyenas can devour a whole zebra, including the bones, with very little left over in just half an hour.

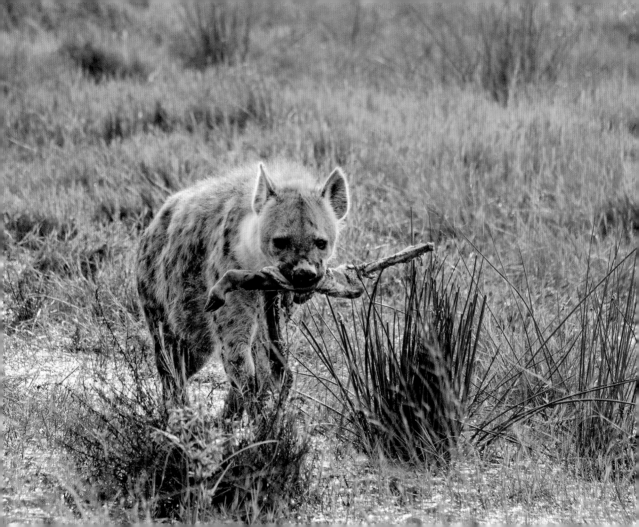

We never know the love of a parent until we become one ourselves.

HENRY BEECHER WARD

MOREMI GAME RESERVE | OKAVANGO DELTA | BOTSWANA

When a female cheetah is about to give birth to her litter, which can be as few as two and as many as eight cubs, she searches out a good hiding place within tall grasses or in rocky outcrops. At first, she must leave them behind to hunt, but by the time they are six weeks old, the cubs can accompany her. When they reach the age of two years, they are strong and independent enough to leave their mother.

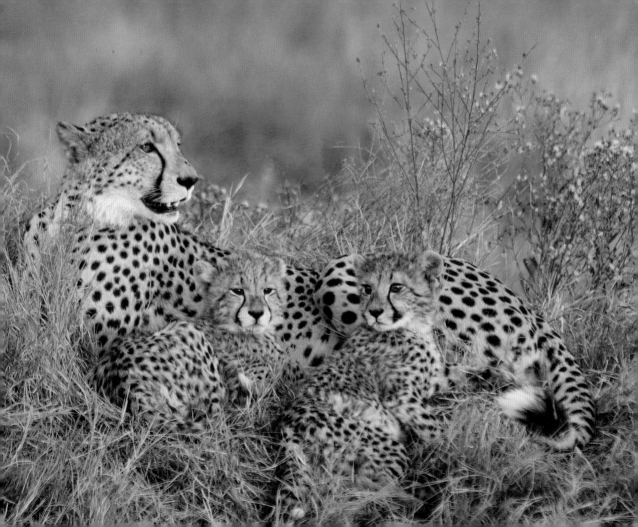

When you are curious, you find lots of things to do.

WALT DISNEY

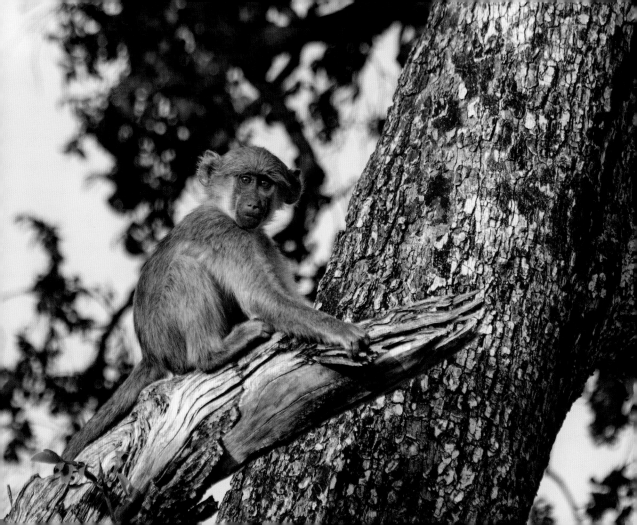

All that I am or ever hope to be
I owe to my angel mother.

ABRAHAM LINCOLN

Female African leopards have two to three cubs at a time. After two years or so of being protected by their mothers, and learning from her how to hunt, the cubs are ready to leave her and live on their own.

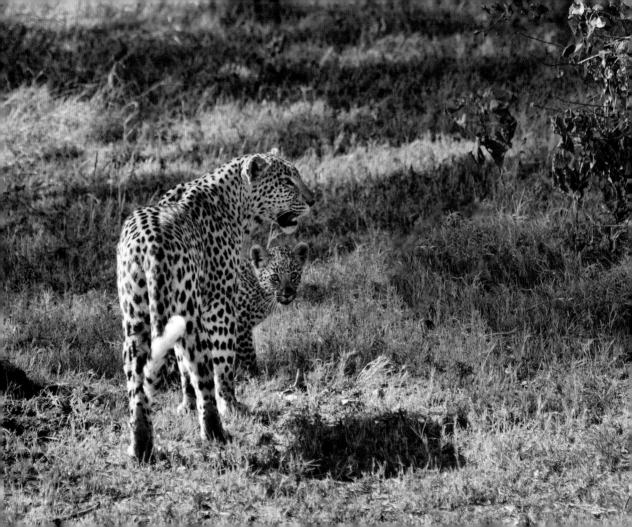

There is nothing on this earth more to be prized than true friendship.

THOMAS AQUINAS

Puffins spend most of their lives out on the sea, resting on waves when they are not swimming.
Their beaks grow and change color during the year from dull to a bright orange in mating season. They are
nicknamed "Sea Parrots" and some say they cannot fly unless they can see the ocean.

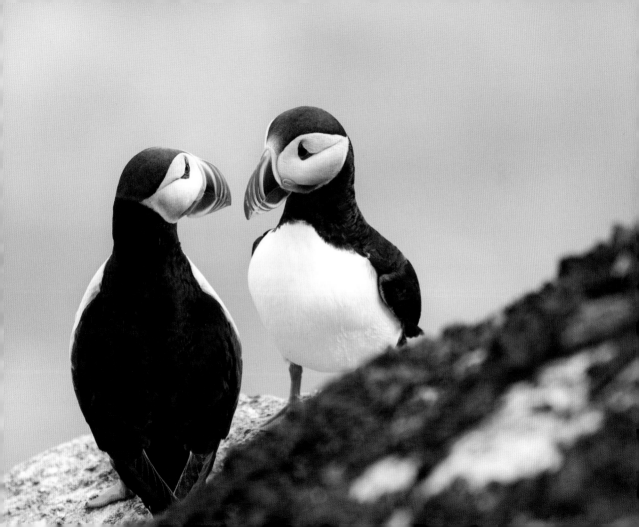

When you come to the end of your rope, tie a knot and hang on.

FRANKLIN D. ROOSEVELT

Orangutans are the only great apes found in Asia. Currently, they are found on only two islands, Borneo and Northern Sumatra. They are the largest mammals capable of living in trees and spend over 90 percent of their lives high off the ground. Their arms are longer than their bodies, and can be up to eight feet from hand to hand which helps them swing from branch to branch. Orangutans are highly endangered and no more than 800 exist in the wild.

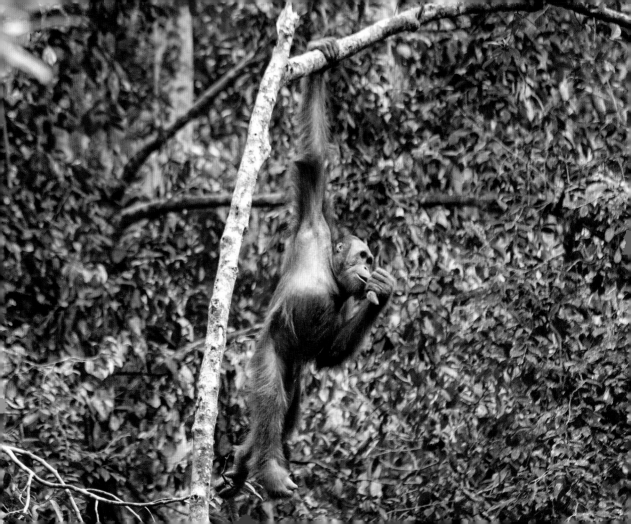

Not all those who wander are lost.

J.R.R. TOLKIEN

TRIPLE D RANCH | KALISPELL | MONTANA
Mountain lions are also called cougars, pumas, and panthers. They are listed in dictionaries under more names than any other animal. Historically they were in virtually every one of the lower United States, but hunting and loss of habitat shrunk their ranges to Florida, Texas and the western United States.

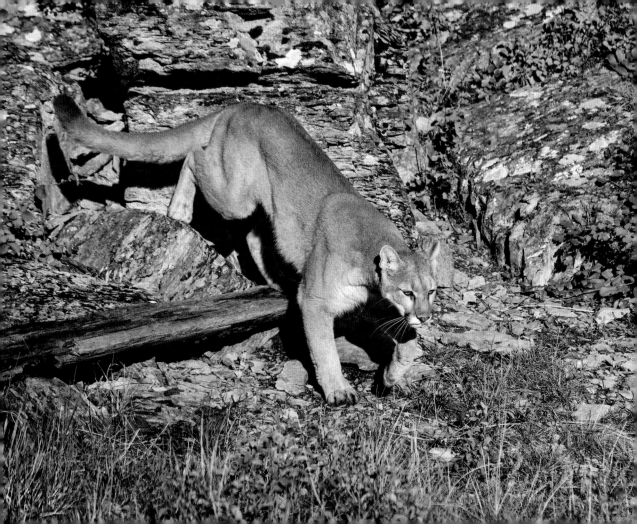

Necessity is the mother of invention.

PLATO

MOREMI WILDLIFE RESERVE | BOTSWANA
A giraffe's neck is too short and his legs too long to allow him to reach ground water. In order to drink, he spreads his front legs wide, but this awkward position leaves him quite vulnerable to predators. Fortunately, he only needs to drink a few times weekly, since he is able to get enough moisture from the leaves his strong tongue strips from shrubs and trees.

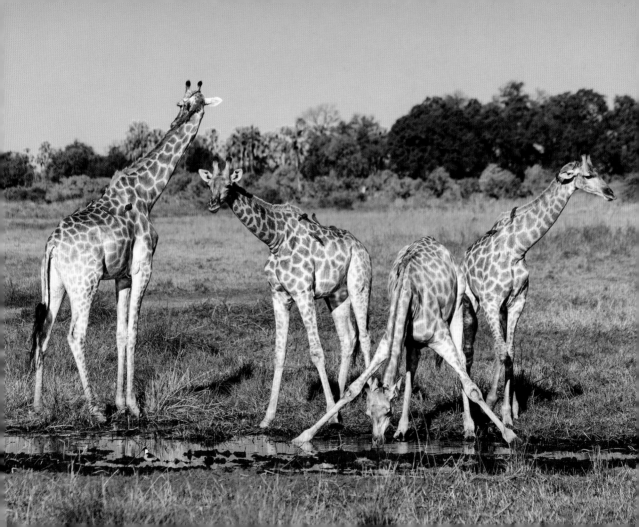

Blessed are the curious for they shall have adventures.

LOVELL DRACHMAN

MALA MALA GAME RESERVE | SOUTH AFRICA
Cheetahs live in southern and eastern Africa. They are the fastest mammal in the world, able to run at 65 miles per hour. They can accelerate to this speed in one to three seconds, but their chase for prey is short, covering over 200-300 yards and lasting less than a minute.

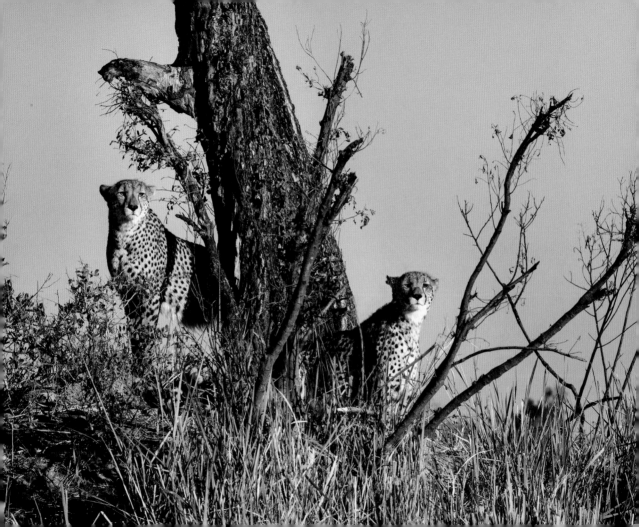

The best thing you can do for your children is love their mother.

THEODORE HESBURGH

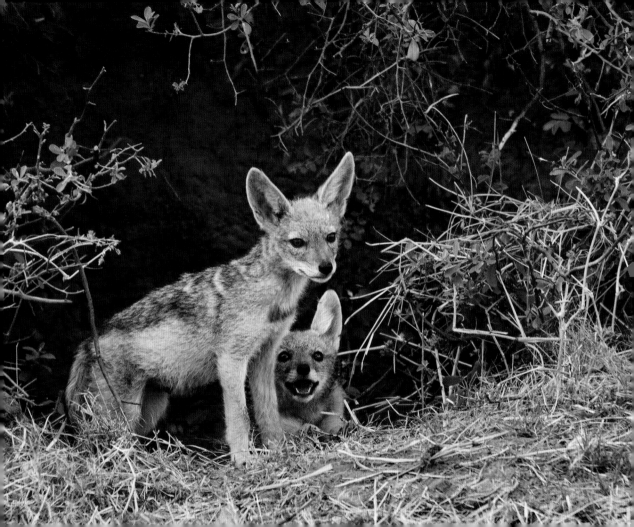

No matter how much cats fight, there always seem to be plenty of kittens.

ABRAHAM LINCOLN

TSWALU KALAHARI RESERVE | SOUTH AFRICA

Lions are very affectionate, greeting each other after sleeping or when returning to the pride. They often rub noses, lick each other, and purr. However, during the mating season, the female attempts to fight off the male. Cubs in the same litter can have different fathers.

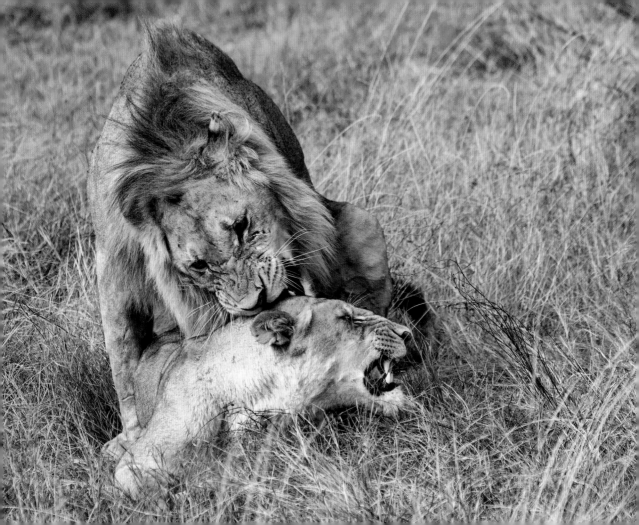

A baby fills a place in your heart you never knew was empty.

UNKNOWN

LINYANTI WILDLIFE RESERVE | BOTSWANA

The Tseebee (pronounced Sess-ah-bee) is one of 72 species of antelope in Africa and is the continent's fastest antelope with speeds up to 50 miles per hour. The Tseebee is a grazer and feeds on grasses in its natural habitat.

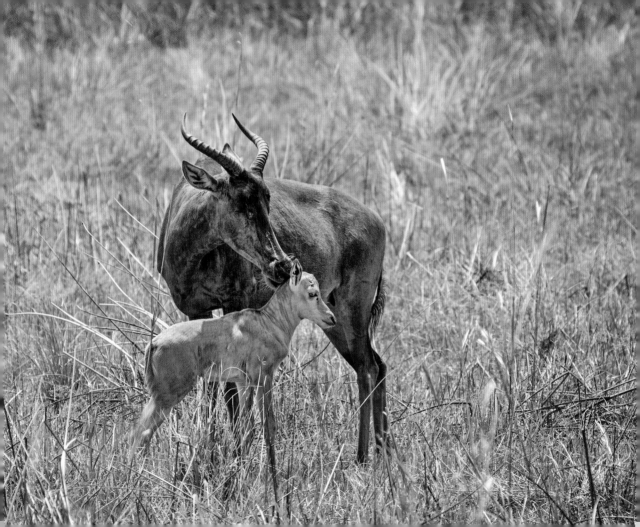

The pain of parting is nothing to the joy of meeting again.

CHARLES DICKENS

NORTHERN TULI GAME RESERVE | BOTSWANA
Elephants are quite intelligent, even fabricating and using tools with their flexible trunks. They are quite affectionate with each other, and mothers help each other with their young. The herd exhibits a collective grief when a member dies.

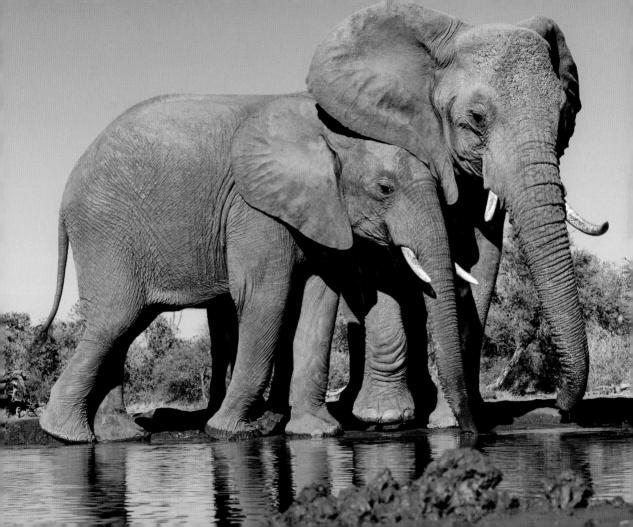

Splish Splash I was taking a bath…
How was I to know there was a party going on?"

BOBBY DARIN

NORTHERN TULI GAME RESERVE | BOTSWANA

African glossy starlings have emerald blue and purple feathers that glimmer in the sunshine.
Starlings like to sit in tree tops above predators like cheetahs and leopards and cry warnings. Like other
birds, they take baths to clean off dust and remove parasites.

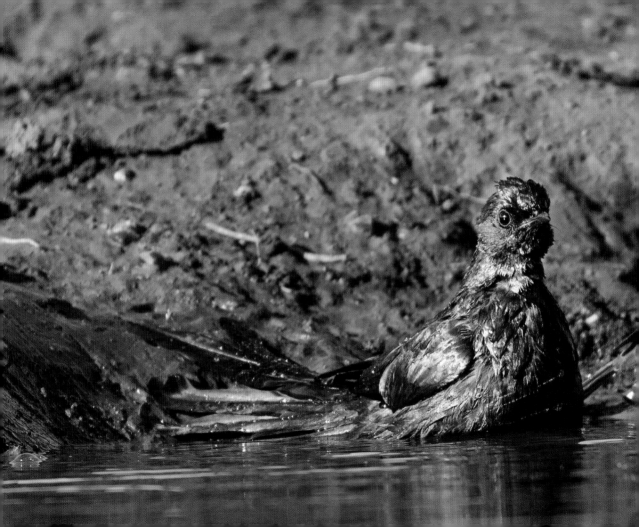

The family is our link to our past, and the bridge to our future.

ALEX HALEY

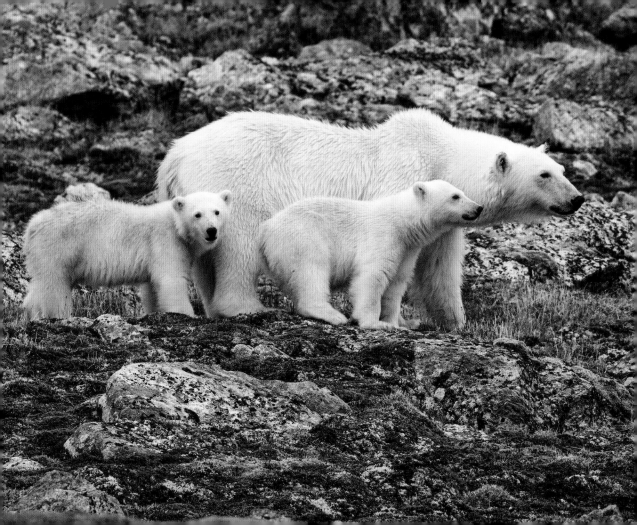

A child is the anchor that holds the mother to life.

SOPHOCLES

MALA MALA GAME RESERVE | SOUTH AFRICA
Female elephants, after a 22 month pregnancy, deliver a huge baby. The little one can weigh in at 200 pounds and stand to a full three feet. The baby can live to be 50 years old.

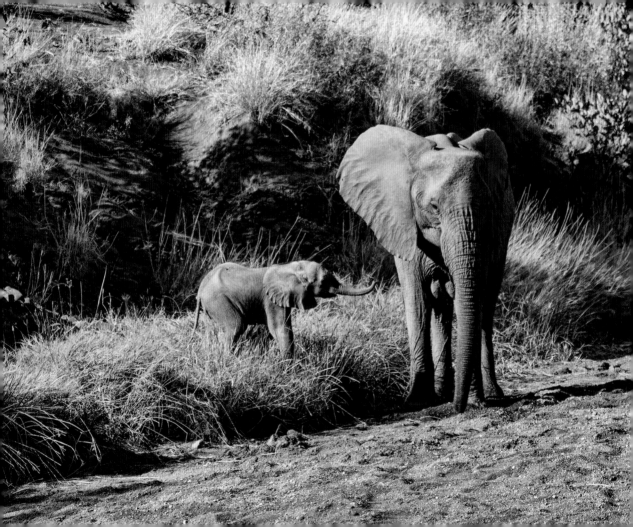

The cries of the stomach silence those of the conscience.

MARGUERITE GARDINER

CUIABA RIVER | PANTANAL | BRAZIL

Brown capuchin monkeys, found in South America, are highly intelligent. They display the ability to plan, and have great dexterity. These monkeys have been known to use tools like a stick or rock to crack open nuts and coconuts.

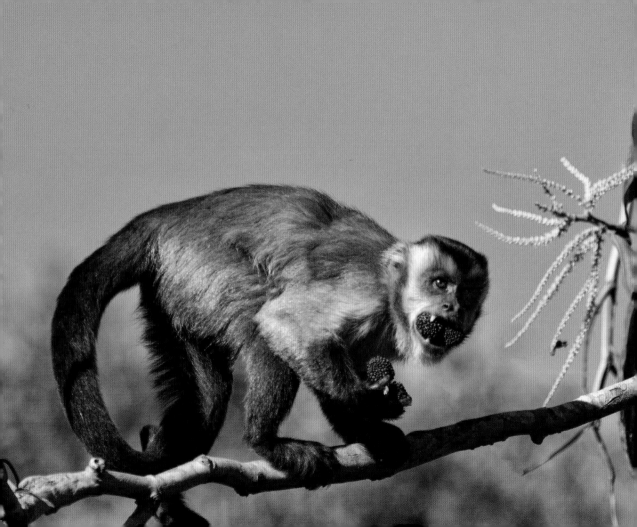

If I had known how long I was going to live, I would have taken better care of myself.

MAE WEST

RUAHA NATIONAL PARK | TANZANIA
A lion's life is not easy! A lioness sometimes gets beat up when hunting. For example, a giraffe or a buffalo may kick her. Lions also sometimes fight with lions from other prides over food, females or territory.

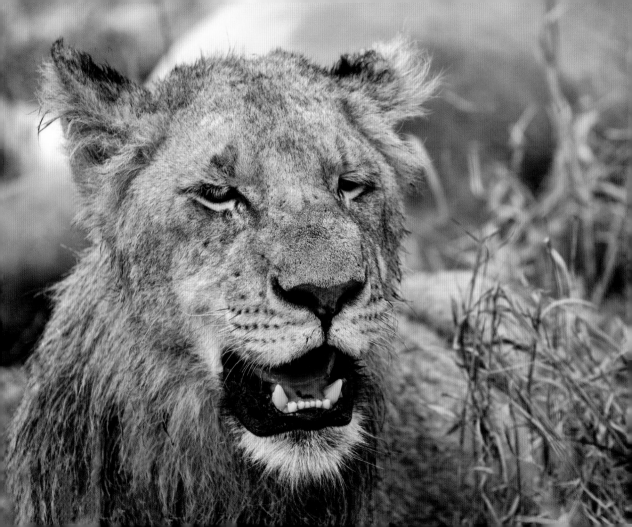

Little by little the bird builds its nest.

FRENCH PROVERB

CUIABA RIVER | BRAZIL

The jabiru stork is one of 19 species of stork. Storks live about 30 years and are found on all continents except Antarctica. They make large nests and reuse them for many years. In Victorian times, when children asked where they came from, a frequent answer would be "The stork brought you." Since storks frequently nested on house rooftops, this could be believable to a child.

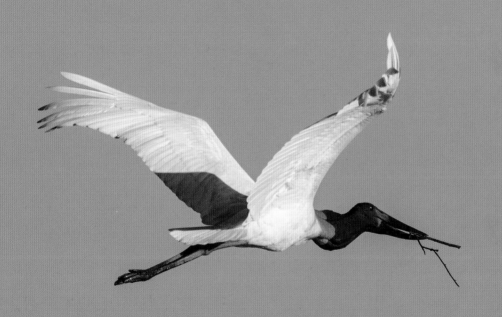

There is no love, no friendship like that of the mother for the child.

HENRY WARD BEECHER

Vervet Monkeys, like other monkeys, spend several hours every day grooming each other to clean out insects and dirt. They are about the size of a housecat and spend almost their entire lives in trees with their group, called a troop. The busy chattering troop is made up of 10 to 50 individuals.

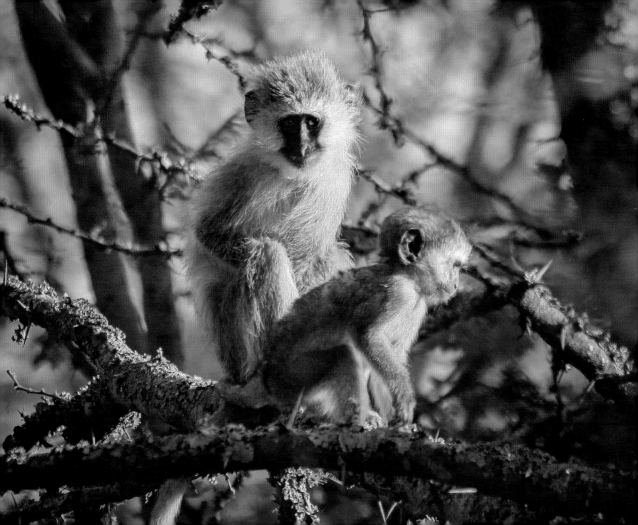

Caution is the eldest child of wisdom.

VICTOR HUGO

TRIPLE D RANCH | KALISPELL | MONANA

Fisher Cats aren't really cats, nor do they eat fish. They are members of the weasel family and eat mostly small animals. Oddly, they like to catch and eat porcupines and manage to do so without getting stuck with their quills!

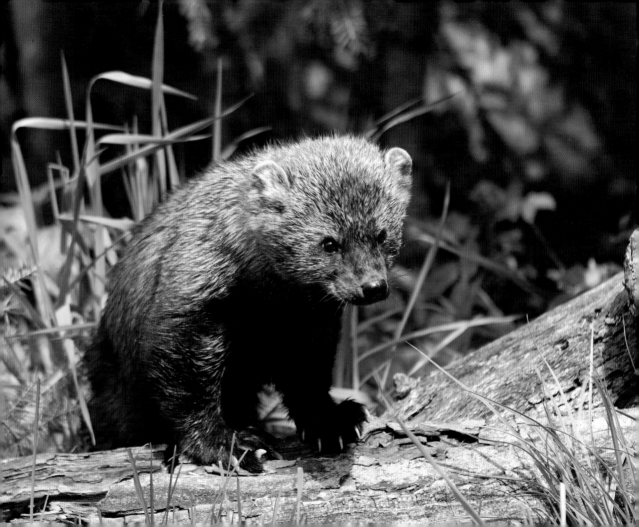

If you want to keep a secret, you must also hide it from yourself.

GEORGE ORWELL

The hippopotamus name comes from the Ancient Greek name "River Horse". Their skin is very sensitive to the sun and they live submerged in water all day long, resurfacing every three to five minutes to breathe. In the night, hippos go up on land and spend four to five hours grazing.

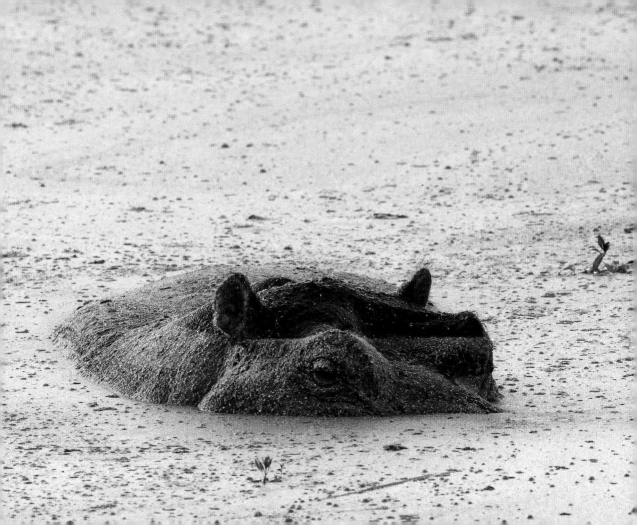

Perhaps dirt isn't as unhealthy as one is brought up to believe.

AGATHA CHRISTIE

TSWALU KALAHARI RESERVE | SOUTH AFRICA

When not holed up in the underground den sleeping overnight with his family, the meerkat spends most of the day looking for food. He locates insects underground by sensing vibrations, then digs for the insects with his long, sharp claws. A juicy scorpion is a great prize.

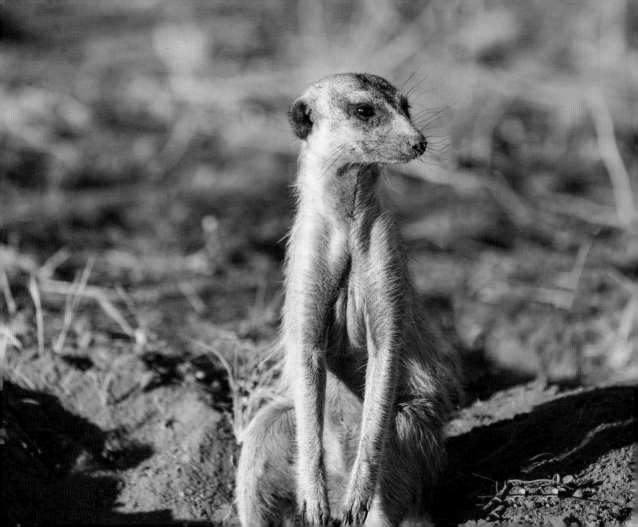

Whatever our souls are made of, his and mine are entwined.

EMILY BRONTE

CHIEF'S ISLAND | OKAVANGO DELTA | BOTSWANA
Young cheetahs leave their mother when they are about 16 to 24 months old. Young brothers will frequently stay together and hunt as a team, but females are solitary except when mating or having cubs of their own. The cheetah's tail is long and flat. It acts like a rudder to aid them when they run.

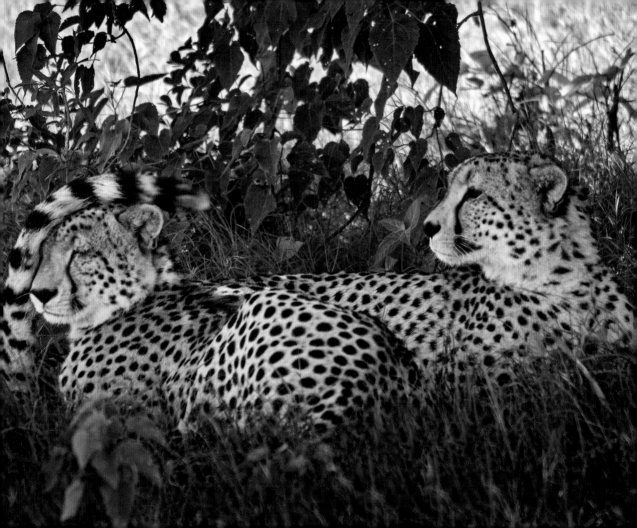

Curiosity is more important than knowledge.

ALBERT EINSTEIN

MAKALOLO PLAINS | HWANGE NATIONAL PARK | ZIMBABWE
Wild dogs, also called painted dogs, have an alpha male and female leading their packs. The alpha female gives birth, usually to two to 20 pups. No other females in the pack give birth. The whole pack helps take care of the puppies. After a successful hunt, they return to the den and regurgitate food for the pups to eat.

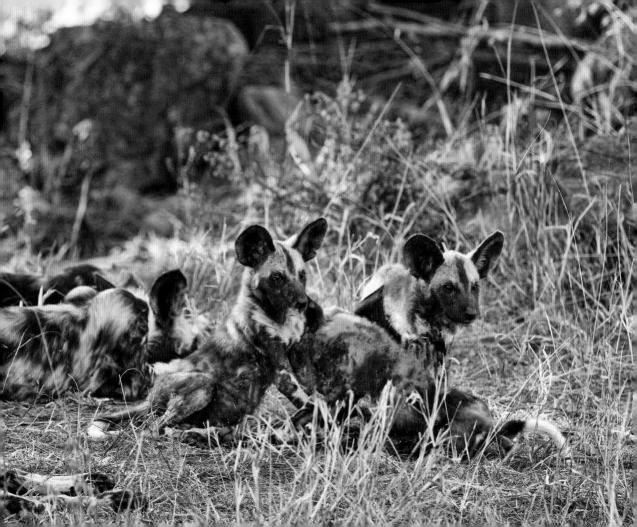

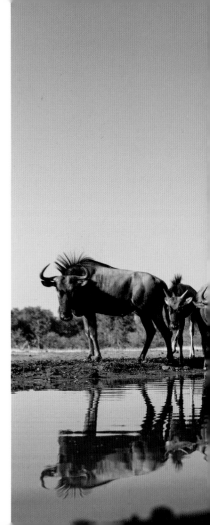

The best place to hide is in a crowd.

UNKNOWN

NORTHERN TULI GAME RESERVE | BOTSWANA
Wildebeests, also called gnus, live in large herds in eastern and southern Africa. They are well known for their annual migration. About two million animals follow the rains searching out the new grass on their 800 mile journey from Kenya to Tanzania and back again. Strangely, every year, about 500,000 calves are born within the same three week period. No one knows for certain why this happens. The calves can get up and move around in herd within 15 minutes of their birth.

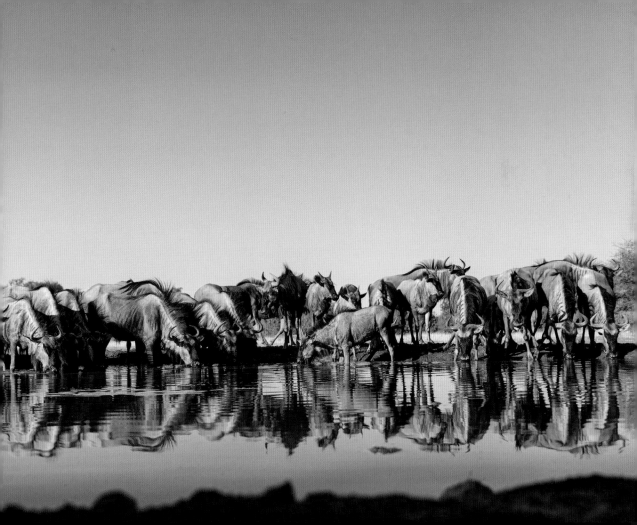

It is not what you do for your children but what you have taught them to do for themselves that will make them successful.

ANN LANDERS

COOK'S INLET | ALASKA
Grizzly bears eat fish, small rodents, plants, insect, and animals like sheep and elk. Their diet depends on what foods are available by season in their territories. In certain locales, mother bears teach their cubs to dig for clams when the tide is out. Their long, sharp nails facilitate the clamming.

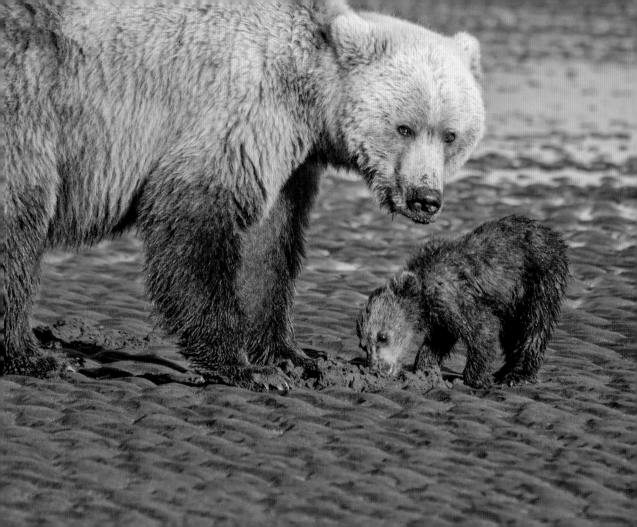

**What is man without the beasts?
If all the beasts were gone, man would die
from a great loneliness of spirit.**

CHIEF SEATTLE

Rhinoceros' horns are made of keratin, the same substance making up human fingernails. Sad to
say, poachers often hunt rhinos for this horn, because many people believe falsely that it has great medical
potency. Rhinos love to take mud baths to keep cool on hot summer days in Africa.

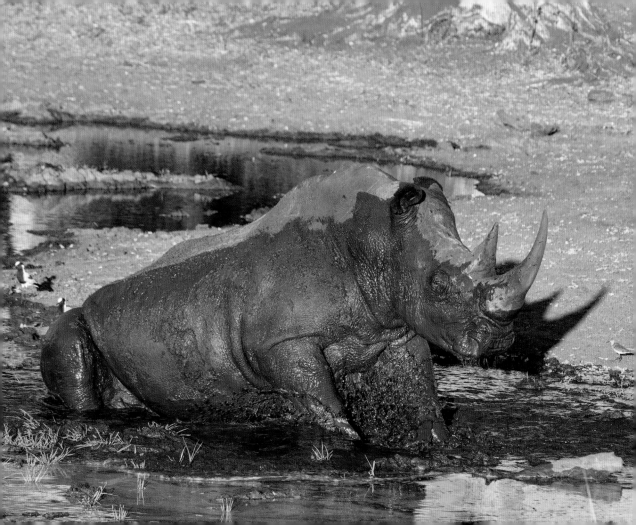

Judith Hamilton is a graduate of the Intensive Photography Program at Rocky Mountain School of Photography which she attended after a 35 year career in Information Technology. Her photography has been displayed in many venues including a six month display of endangered animals at Google Headquarters in Silicon Valley. She has two permanent exhibits of wildlife on display at the Palo Alto Medical Foundation (Sutter Medical Group) "Mothers and Babies" and "Endangered Animals". She has won several photographic contests including Julia Margaret Cameron and Pollax Awards. Her images have been printed in numerous magazines and calendars. A previous book, *Animals A2Z*, was distributed at the Bronx and Central Park Zoos and *Animal Expressions* is available there, at Amazon, and other outlets.

Judith has served on many private, public and not-for-profit boards of directors including Wildlife Conservation Society, and The National Parks Foundation. She was CEO of several computer software and service companies in Silicon Valley prior to reinventing herself as a photographer.

Judith Hamilton
Email: judy@JudithHamilton.com
Web: www.JudithHamiltonPhotography.com
Facebook: facebook.com/judithhamiltonbooks

Published by Judith Hamilton Books

Austin, TX

www.JudithHamiltonPhotography.com

Distributed by Greenleaf Book Group

For ordering information or special discounts for bulk purchases, please contact
Greenleaf Book Group at PO Box 91869, Austin, TX 78709, 512.891.6100.

Publisher's Cataloging-in-Publication data is available.

Print ISBN: 978-1-7342260-0-3

Part of the Tree Neutral® program, which offsets the number of trees consumed in the production
and printing of this book by taking proactive steps, such as planting trees in direct proportion to the
number of trees used: www.treeneutral.com

Printed in China on acid-free paper

20 21 22 23 24 25 10 9 8 7 6 5 4 3 2 1

First Edition